YOUR CAREER AS AN

ART DEALER

GALLERIES, AUCTION HOUSES

ART DEALERS ARE ESSENTIALLY SALES PERSONS. They sell art and occasionally buy some themselves, although usually for the purpose of reselling it. In a sense, the art dealer is no different from people selling cars or real estate. The more they know about the product they are selling, the better the job they can do. As an art dealer, especially, you need to know everything about what you are selling. Everyone selling art is going to be passionate about it, urgent to champion some new visionary or to defend an Old Master who has gone out of fashion but whose work still radiates wonder. If you are already excited about art, you are starting from the right place.

A career as an art dealer is something you should seriously consider, even if what you are mostly concerned with is the work you do as an artist yourself. In fact, many of the people working in the art market are themselves painters, sculptors, photographers, or other artists. There is a long tradition, dating back to the origins of art dealer as a profession, of artists who were also dealers. It was often the case that the artist with the best business sense would emerge as representative for his/her own works also those of friends and colleagues.

You could do the same today, although new galleries that open today are usually owned and operated by people who are more intent upon being dealers than artists themselves. These new dealers are usually taking the step to open their own business after having spent a few years gathering experience in other galleries or auction houses, while at the same time diligently scouting for artists whose work they admire and who are not represented exclusively by another gallery.

What is critical, if this is a career that is appealing to you, is that you learn as much as you can about art, past as well as present. You will be entering a world of bright, well-informed people, with little room for anyone trying to fake it. In the highly competitive art world, you need to be the real deal if you want to get to the top.

You might even, during your high school years, come upon that special period or style that you want to make the focus of your life's work. It may be the first time you see a great work of classic art, like The David of Michelangelo; or something more modern, like a drip painting by Jackson Pollack; or something completely different from anything you have seen before, like a pop art construction by Red Grooms. You will want to keep expanding the scope of your knowledge so that your favorite works can be understood and explained in the context of the entire panoramic global history of art.

The art world can be very fickle and fashion conscious, lifting you up one year, when your gallery lands new artists who suddenly become the defining visionaries of the moment, then dashing you into despair the next year, as the market moves on and your artists have become yesterday's news that no one cares about any longer. You need to be extremely resilient to continue in this career, unless of course you achieve great success early on and are that rare dealer who goes from one success to another without ever a misstep.

Besides intelligence, luck, passion, and resilience, it will help to be charming and graceful. Artists, especially the really good ones, can afford to be rough and uncouth, with no particular regard for social skills. Art dealers and the people who work in galleries and auction houses will frequently find themselves in social as well as business situations (often one in the same, as in an opening party for a new exhibit) with the wealthy and powerful. Proper manners allow you to be polite without being subservient or pushy. A touch of class never hurt anyone anywhere, and especially not in the art world.

THINGS TO DO NOW

A GREAT WAY TO BEGIN ON YOUR PATH to a career as an art dealer is to paint, sculpt, and take photos yourself. If your school does not offer any art classes, there are sure to be some at a local museum or in an adult education program nearby. Actually having hands on experience will make it easier to converse with the artists and clients you will come to deal with, giving you the ability to understand the work from the artist's point of view and discuss technique knowledgeably with clients, as well.

You will want to go to all the museums you can get to as well as to any art galleries and antique stores in your vicinity. Be sure to check local community calendars for art shows and fairs, auctions, and estate sales in your area. Add to that, visiting flea markets and yard sales. By experiencing all of these venues, you will have a great opportunity to view a broad spectrum of great art, good art, bad art, valuable artifacts, and awful junk. As an art dealer, you will often be called upon to sort out different qualities of art and learn how to value them. You will need to train yourself to find that diamond in the rough.

If there are any art galleries or auction houses in your area you should try to interview any of the people involved for their insights and lessons they have

learned on the job. You might also seek out any leads you can find to local private collectors who might be willing to open their homes to let you see what they have collected and to discuss the choices they have made, how they might have developed a taste for a specific genre, and how they learned to distinguish among the pieces they consider purchasing.

You can also become a collector yourself. No one is expecting you to discover the next Picasso while you are still in high school. Nevertheless, you are certainly ready to begin developing your own tastes and preferences. Of course, collecting can be an expensive hobby, but you may be able to find prints or reproductions of artists and works that appeal to you. Having to make decisions about what you can afford to buy might help you to understand the mental process of your future clients as they go through their decision-making.

You do not have to wait until you are working at a gallery or auction house to organize your own events. Schools are always having antiques sales and other charitable events in order to raise funds for teams or other school needs. You can step up and organize an auction. Ask parents or students to offer something of value they are willing to part with, not unlike what happens at a yard sale. You can create your own on-the-job training program!

Whether or not your school has any art classes, it should offer business courses and language courses, both of which will be of great value in your career whether you are working for someone else or for yourself. French, German, Spanish, and Italian can all be of value when working in the international world of art. If available, try Chinese or Arabic, both of which are sure to be of value in the developing global art market.

Read about the lives of the great artists and art dealers. An entertaining book is *Duveen: The Story of the Most Spectacular Art Dealer of All Time*, by S. N. Behrman. You might also try Rachel Cohen's *Bernard Berenson: A Life in the Picture Trade*, about the art critic and historian who was Duveen's secret partner.

In addition, read art magazines. You will pick up information about galleries and auction houses, their activities, owners, and managers. More importantly, you can begin to follow trends in the art world to get an idea of what is hot, what is not, and how to predict what will be hot tomorrow.

HISTORY OF ART DEALER AS A CAREER

ART DEALERS ARE AN INTEGRAL PART of the modern art scene, but the profession has only been around for about 500 years. Prior to that, artists dealt directly with their patrons – individuals as well as religious and civic organizations – who commissioned their work. Artists might exhibit their work at fairs or in markets, or display pieces they had for sale in their studios or shops. Typically, buyers and sellers (who were usually the artists themselves) were on their own. This is a bit surprising since wealthy patrons had been collecting art since the age of classical Greece and Rome.

Art dealer emerged as a recognizable profession in The Netherlands and other parts of Northern Europe in the early 1600s, during a period often referred to as The Golden Age of Dutch Painting. The earliest dealers were often painters who found it necessary or preferable to take a commission for selling the work of other artists. The creation of art fairs helped to speed the process. In addition, auction houses became an active part of the art scene in this period. Besides artists, the first art dealers were also merchants. For them painting and other works were just additional products to take to market in exchange for a small percentage of the value in the exchange.

In the 18th century, the need for art dealers increased as Europeans began to travel more for educational as well as commercial purposes. Exposure to the art of other countries and especially to the art of antiquity created a new generation of collectors and a need for professionals who could procure the desired works at the best prices, as well as helping collectors with advice on what were the most valuable and desirable paintings and objects. Professional critics also emerged in the 18th century, further spurring interest and demand for fine art. Art galleries also began to appear as dealers strove to expand the number of potential buyers by showing off their merchandise in a retail setting.

The late 18th century saw a notable increase in the number and activity of auction houses. These were usually involved with disposing of the collections of great families that had fallen on hard times or reached the end of their hereditary lines with no one left to inherit all the works that had been accumulated. It was also a period in which auction houses took to operating in fashionable neighborhoods as befit the social level of their clientele.

From the late 18th century into the 19th century aristocrats began facing competition in the purchasing of art from a rising class of wealthy entrepreneurs, industrialists, and capitalists, such as the Rothschilds, the Vanderbilt family, J. P. Morgan, Andrew Carnegie, and Henry Clay Frick. The late 19th century saw several art dealers begin to specialize in selling works from different periods and styles of art. Some European art dealers, such as Paul Durand-Ruel and Paul Cassirer, chose to champion painters who were changing the entire approach to painting, like the Impressionists. These dealers were so committed to their artists that they supported them financially until the days when their paintings began to sell.

In the late 19th and early 20th centuries, the first real superstar art dealers would emerge. This was contemporaneous with the rise of the United States as a world power. One dealer, who both advised and sold art to the wealthiest families in the US was Joseph Duveen. He so dominated the field that art historians sometimes refer to the early years of the 20th century as "The Age of Duveen."

The last century has seen the continuation of the specialization of dealers and their galleries in one specific style of art. It has also seen the rise of international galleries with a single owner representing artists through galleries in all the major world markets. Larry Gagosian, founder of the Gagosian Gallery Group, is often cited as the leading force in this globalization effort, with 11 galleries located in seven countries from New York to Hong Kong.

In addition to globalization, the rise of the Internet in the modern era has introduced a new element into the art market. There are now online galleries offering original art by up and coming artists, as well as prints and reproductions of established works. They are reaching a new audience of consumers who are accustomed to shopping online. Some online galleries include curators and advisors with extensive retail gallery experience who can offer guidance and insight to new buyers and collectors.

WHERE YOU WILL WORK

ART DEALERS TYPICALLY WORK IN galleries or auction houses. Auction houses tend to be housed in large buildings that have rooms for the storage of the works to be auctioned off, as well as a considerable space that can accommodate a large number of people coming to place bids on items up for sale. Of course there will be office space, as well.

The headquarters for Sotheby's, in New York, one of the largest and best-known auction houses, is a 22,000-square-foot, 10-story building that features exhibition space on six floors, a nine-story glass atrium and galleries designed by museum architect Richard Gluckman. It also includes a state-of-the-art lighting system that the company proudly notes, "enables nuances and subtleties of color and surface to be strikingly revealed. No other auction house, regional or international, can offer such extraordinary visual impact."

Art galleries vary in size and style, depending on their location. In New York City, which probably has the largest concentration of galleries in the US, if not the world, galleries can be found in lofts in the renovated old warehouses that are now part of the scene in trendy SoHo, the Lower East Side, and Chelsea, as well as in the newly chic neighborhoods of Brooklyn, such as Williamsburg, where young artists are flocking in pursuit of cheaper rents and more studio space. New York also features fashionable galleries in storefronts and elegant mansions standing side by side with jewelry and apparel shops along the desirable side streets and avenues of the Upper East Side.

In other towns and cities, where there is more space, galleries can take up an entire building. They might even be an extension of an artist's home or studio. Of course, an online art gallery can be located just about anywhere, although a place with good storage space and easy access to transport services like FedEx and UPS is preferable.

Within an auction house or gallery, you may find yourself in the front of the house, dealing with the public, clients, and artists. Or you may spend your time in the back office, dealing with orders, cataloging goods, shipping works to clients, or preparing gallery space for the next exhibition. You may also be part of a team that goes out to fine homes where the furniture, art, and collectibles are going to be put up for sale in order to conduct an appraisal of the properties. You may go to an auction that takes place on

site at the estate itself rather than back at the auction house.

Because of the increasing globalization of the art market, you may find yourself on planes, working in your gallery's exhibit at art fairs, visiting artists you represent to see their new work, attending meetings at the overseas locations of your own gallery, and checking out exhibits at rival galleries or auction houses. Wherever you go, you will be visiting museums, artist studios, and outdoor installations in the search for new talent and new directions.

THE WORK YOU WILL DO

ART DEALERS WORK ON TWO FRONTS: looking for talent to represent and looking for clients who will be interested in buying the work of those artists. The dealer, whether starting out or well established, seeks out new talent, always aware that the market is driven by the new, different, and unexpected. This requires networking with other artists, dealers, and critics who are all observing the ever-changing art scene just as you are. The dealer carries on the research in person, on the phone, through emails and social media, and through voracious reading of art magazines and online sources.

The work of finding the right artists can be a dead end unless you have the ability to sign them. Which means that your operation needs to be impressive enough to make an artist want to work with you. The same is true in terms of the collectors and museums that you need to bring on board as buyers. To that end, the dealer may have to spend time fundraising, possibly selling shares in the gallery to investors, in order to have the money needed to create a positive impression. This work is usually done at the top level of the gallery by the owner or the gallery director.

Gallery Director, Manager, Administrator

Galleries may use the terms director, manager, and administrator to mean the same overall management position at the head of operations, and reporting to the gallery owner (unless the director is also the owner or one of a group of owners). This manager works with the gallery owner and other management personnel to see that the day-to-day affairs of the

gallery are in order.

The position can include greeting clients and being part of the team that organizes exhibitions and participation in art fairs. There is work doing basic bookkeeping and record keeping, producing invoices and other sales and purchasing documents, as well as consignment notes, and updating the gallery databases of artworks, artists represented, and clients.

A gallery director may, in some instances, be responsible for the gallery's online presence, handling website maintenance, e-marketing, and other aspects of the gallery's social media presence. Larger galleries can afford to hire someone or use an outside service for this function.

To the extent that the terms can be differentiated, the use of the director name suggests a more creative aspect in helping to set the style and focus of the gallery. This is especially the case when the director is also an owner. The director would be the face of the gallery to clients and potential clients as well as to the artists and to the media.

A manager would be more likely to oversee all of the daily operations of the gallery but, if there is a separate director, be less likely to handle outreach. The same would hold true for an administrator who would, if there are also a director and manager at the gallery, be more hands-on in terms of taking care of all the logistics of the plans initiated by the other executives.

Among the specific tasks for which a gallery's leadership, whatever the title, would be responsible for are:

- Exhibition planning
- Public relations
- Sales
- Inventory management
- Facility maintenance
- Database management
- Art Fair exhibits
- Artist relations

Specialists

In auction houses, especially the larger firms that deal in a broad variety of items, there will be a staff of specialists who are experts in particular areas of art or antiques. An auction house such as Bonhams, a venerable institution founded in 1793, will employ dozens of these specialists who evaluate and appraise everything from aboriginal art, to old master paintings, coins and banknotes, armor, and classic cars. A senior specialist will usually be the manager of a department dedicated to a particular area.

In addition, specialists work to develop a network of contacts that allow them to identify artworks and items that are becoming available for auction, and the communication and negotiating skills needed to land the consignment for their auction house. Specialists usually have a background in art history and may also hold a diploma from the Institute of Professional Auctioneers and Valuers.

Appraiser

Art appraisers evaluate antiques, paintings, and other art objects in order to determine a fair market value, that is a price that a buyer and seller would likely arrive at in an ideal world. They are more likely to be engaged either on staff or on a contract basis by an auction house more than a gallery. It is not unusual for appraisers to specialize in particular periods or styles, developing an expertise that enhances their judgement. In a gallery setting, the appraiser may be dealing with new works of art, helping the dealer to determine what price to ask based on current market conditions for similar works in terms of style and the artist's reputation.

Archivist

In art galleries and auction houses, archivists organize and maintain the records related to each specific artwork, antique, collectible, etc. Their work is critical in determining the rights of ownership of each object by means of a careful tracking of the transactions in which items changed hands between owners, beginning, if possible, with the artist. This evaluation of authenticity is called the provenance of the artwork, and it is critical to its value and sales price. Archivists are usually more important to auction houses that deal with antiques as well as new works, because ownership can be challenged during an estate sale. The records kept by an archivist can include bills of sales, wills, maps, letters, photographs, legal documents, birth certificates, medical records, etc. They may be kept in paper and/or electronic formats.

Artist Liaison

Not every gallery will have personnel devoted to providing personal and individual attention to the needs of the artists whose work it represents. In a small gallery, the director will communicate directly with artists. In a larger gallery, there may be an employee whose sole responsibility is to be there to service the gallery's artists, helping them, as the need may arise, with anything from purchasing airline tickets, to getting their taxes paid, to buying something to wear to the opening of their exhibit. This is obviously a position that requires a strong sense of diplomacy and a great deal of patience and attention to detail.

Preparator

The job of an art gallery preparator is wide ranging and can include the displaying, storing, cleaning, cataloging, securing, shipping and receiving, and installing of art exhibits. The preparator might build cases or frames, and design, hang, and focus the lighting for an exhibit. In some galleries, preparators are responsible for security during an exhibition, and in others for the general maintenance of the facility.

Registrar

Art gallery registrars often work closely with preparators, as a kind of project manager overseeing the installation and removal of exhibits, keeping track of schedules, keeping records of all stages of a project, as well as maintaining the database for all the gallery's holdings. The registrar is usually the gatekeeper when it comes to accessing the database. Another key responsibility is to generate reports on the condition of each of the holdings and also the conservation steps being taken.

Registrars may also be responsible for generating and maintaining legal documents related to exhibitions and collections, including loan agreements, loan requests, insurance policies, donor acknowledgment letters, and tax and gift forms. They may also maintain client and donor files.

Gallery Assistant

In the entry level but still extremely important position of gallery assistant, the work you do will cover a wide range. One day you may find yourself assisting the registrar in updating the gallery database, and the next day you may be working side-by-side with the preparator hanging lights for an

exhibit. At an opening you may be serving hors d'oeuvres or introducing the artist to a guest. After the event, you may be in charge of cleaning up the gallery. A good assistant will take advantage of the situation to learn everything there is to know about gallery operations.

Gallery assistants are called upon to attend art fairs, commercial gatherings of many galleries and dealers who pay a fee in order to offer an exhibit. Gallery assistants may be needed to participate in installing an exhibit and then stand by to hand out materials about the gallery or talk to visitors about the artists whose work is being shown. While providing support at an art fair may be laborious, it can present a chance to do some traveling. Art fairs may be a local affair, but they can require going to another part of the country or even overseas to one of the great international fairs in London, Paris, Basel, Venice, Hong Kong, Istanbul, or Abu Dhabi.

ART DEALERS TALK ABOUT THEIR CAREERS

There Was Never Any Doubt in My Mind That the Business I Would Start Would Be an Art Gallery

"I majored in business as an undergraduate with a minor in art history. I did some volunteer work at a gallery while still in college and was lucky enough to turn that into an official internship for which I got class credit, and then into a paying job when I graduated.

After three years, I left the job and went back to my home city. I had enough money to rent a small space but I waited until I had three artists whose work I liked and who agreed to let me show their work as part of one exhibit. I ran myself ragged getting out the publicity for the show and we got a decent crowd. I put my kid brother in charge of getting everyone to sign a mailing list. We sold a few paintings, and I split the money 50-50 with the artists. I was off and running.

I now have about 15 artists who show in my space and one assistant

who works almost as hard as I do. She does get a day off, but I work every day and usually late into the evening before I have to call it quits. The gallery is open every day, and one of us is always there. We try to get as much paperwork done during the day as we can because in the evenings we are usually out networking – fun but exhausting – unless we are in the gallery getting it set up for a new show.

It's been over a decade now, but I still love it and don't regret having made this my life. Despite our success, we are never far from disaster and that still motivates me to work like crazy. I do make it a point to take time off every winter, but I always use that time to scout out new talent in Europe and line up potential clients at the art shows and fairs I go to.

My next big step will be to transform the gallery's website into a real online gallery. Right now it's just an informational site. I'm actually taking a web design class, but I'll probably hire someone who really knows the techniques. I'm scouting other gallery sites looking for a design that works for me and when I find it I'll go after that designer."

My First Job After University Was as a Bookkeeper in an Auction House

"After nine months in the bookkeeping department, I was able to move to a more rewarding position in the appraisal department where I learned to catalog. The thrill of the auction business is very contagious and fast paced.

I began working in 1979, and we did everything manually – bank reconciliations, paper checks, supplies, cashier for sales, other related bookkeeping duties. Today, I oversee the US jewelry team for an international auction house. My duties include meeting with clients, evaluating collections, advising clients, lecturing, writing, training staff, keeping up with industry changes, cataloging, working in catalog production, selling, and traveling.

I love the opportunities I have to keep learning new things and travel to wonderful places. I also get a great deal of satisfaction from knowing that I'm doing my job well. It pleases me that I've got the right set of personal qualities that are needed for the environment I'm in, including knowing how to be personable but also tenacious, and knowing how to stay open-minded, insightful and inquisitive."

My First Class in Art History Changed My Life

"I went to college with no real notion of what I wanted to do with my life except something not dull. That first art class was so exciting I knew I had found something I could do. It just focused my whole being.

As soon as I graduated, I headed to New York City where I'd lined up a job in a gallery that had just gotten really hot, with a dozen artists that were breaking through all at the same time. I couldn't believe my luck! Coming from a relatively small community and suddenly having this opportunity to meet so many important people all at once, the artists and the clients. There were many people like me from the other galleries. We felt very competitive but very close at the same time.

As I got to know the scene I began looking for a gallery whose work I most connected to. I was especially interested in artists from the area where I grew up, the ones who were painting now and the ones who came before. I was fixated on the idea of finding some themes and styles that were related.

After a couple of years I spotted a place that seemed headed in that direction of regional America art, and I applied for an assistant director job there and got it. It took a while to get established but the director came to trust my opinion and listen to my ideas. I'm still working on my dream show, but I'm confident I'm going to make it happen and do it right here in this gallery."

I Am a Sculptor by Training but I Also Work as a Preparator

"Sculpting is good training for being a preparator. You seem to always be dealing with a lot of crates and packaging. I also work with a lot of found objects and bits of machinery and tools, a good background for being a preparator.

I actually started doing preparatory work on a freelance basis while I was still in graduate school. I was good at it, it paid some bills, and I got to network like crazy. You need to be good with your hands. Sculpting is good training for being a preparator. If you don't mind a little physical labor it's a great way to make friends and get yourself known.

At the gallery where I now work I am a jack of all trades, helping to set up exhibits, putting together the lighting, and making sure that nothing goes wrong, like a lightbulb burning out, a trash can getting too full, or someone leaving a smudge on the wall. I did some acting and backstage work when I was in college and I feel that same kind of show biz thrill at being part of the exhibit team.

Although I'm on staff, I don't work any kind of normal hours. There's another preparator on the staff so we have everything covered once an exhibit goes up, although we are both usually there when we're getting ready for a new show. The good thing about it is that I have time to work on my own art and also to have flexibility if I need to go somewhere to put up a show of my own sculpture."

I Graduated From University With a Degree in Japanese Art History

"I landed a job in the Japanese art department of a large international auction house. I worked with a wide variety of art and antiques there, including lacquer pieces, ivory, netsuke and sagemono, Buddhist art, enamels, swords, and armor. It was a great extension of my education, actually getting hands-on experience with items that I'd mostly read about or seen in museums.

After more than a decade at the auction house, a position opened up for the head of Japanese Art at a rival auction house. I applied and was hired! As with the earlier job, my time is spent sourcing, authenticating, evaluating, and selling antiques at auction. I'm fortunate to have been instrumental in bringing some of the largest Japanese art collections in the US to auction with my firm.

My favorite part of the job is meeting collectors and hearing the stories of how collections were formed. It's always fascinating and the stories help to keep me motivated and moving forward when dealing with all the pressures and difficulties of selling. It also really helps to be well organized and know how to get along with a lot of people, including your co-workers as well as the clients, both buyers and sellers."

I Am the Archivist for a Gallery Specializing in Bringing the Art of Australia to the US Market

"I had no previous ties with Australia but have now been there twice to meet with artists and local dealers while helping to get new exhibits organized for our gallery in New York. That's been a fantastic and unexpected bonus of my job.

I have undergraduate and graduate degrees in film, sculpture, and visual arts. I worked in the college library and acquired some organizing skills that helped me land a job as an assistant archivist after I graduated. I learned how to repair damaged books, manuscripts, photographs, and even a little bit about antiques. I also served as the in-house photographer of our exhibits, contributed to graphic and exhibition design, and served as a liaison with other dealers interested in the work we were bringing in.

My work now is mostly about keeping good records regarding the dates, materials used, and time frames related to new works that we bring up from Down Under. It includes tracking down, preserving, and organizing some historical documents and updating the electronic database that includes every document we have in our extensive library on Australian art.

I still have time to do my own work although not everything I was doing before, which included teaching and making video documentaries. Maybe I'll take a break sometime soon and get back to those."

PERSONAL QUALIFICATIONS

WORKERS IN A GALLERY OR AUCTION house often cite the team feeling they experience on a day-to-day basis and especially when mounting a new exhibit or show. The ability to communicate clearly and to understand and follow instructions, and the ability to work well under pressure are all qualities that will be valued in these settings. So, too, will be patience.

These good interpersonal skills also come into play when dealing with clients, artists, and the general public. Art galleries and auction houses aim towards having a touch of class, and if you want to shine in this context, having good manners and an appealing personality are certainly assets. Knowing a foreign language or two is a real plus.

Good organizational skills are also welcome. Things can happen very quickly – perhaps an unexpected visit from an important client – and often involve complex matters, such as the logistics of installing an exhibition of art works with moving parts. Being detail oriented and able to multitask are key components of being organized.

A result of being organized is the ability to be flexible, to adjust to a fluid situation where decisions are being made in the moment as deadlines draw near. This quality is highly regarded as are the ability to be a self-starter and to have accountability. Despite the need for employees who can follow directions, galleries and auction houses want people who can work independently, who are not afraid to make decisions, and who are willing to stand behind those decisions.

Being in good physical health is important, as working in a gallery almost always means lifting and carrying heavy objects from time to time, as everyone is called on to lend a hand. Some ads for gallery jobs carry specific requirements that read along the lines of "Must be able to lift 35+ pounds and help hang art."

ATTRACTIVE FEATURES

PEOPLE WHO COME TO WORK IN ART galleries are often fulfilling a dream that has them in a world of glamour, wit, and beauty. In fact, the art world is filled with intelligent people, who are very verbal, highly opinionated, and often quite perceptive. As a novice just entering the business, you will have the opportunity to encounter people with wonderful stories to tell about art and life. If you are open to learning, you can have a remarkable, fascinating time.

You also have the opportunity in this special world to fulfill your own desire to grow and emulate the people you admire. This is an environment that rewards creativity, imagination, and sensitivity, as well as hard work. As much as it is competitive, if you have the right stuff, it can be emotionally, spiritually and materially rewarding.

Beyond the appeal of working among bright tasteful people, there is the draw of working with the art objects themselves. If you have chosen to make your career in the art world, it is the love of these objects – paintings, sculptures, antiques of all types, or collectibles – that almost certainly has led you in that direction. Being surrounded by them on a daily basis can be wonderful.

In addition, working in the art world can also present you with opportunities to travel both domestically and internationally, and continue to broaden your network of friends and business contacts.

Your impulse to want to be an art dealer stems from your passion for art. There is also the opportunity to become financially well off if you can put together some luck along with your intelligence, insight, and taste.

UNATTRACTIVE FEATURES

ART DEALERS AND AUCTION HOUSES are businesses that exist to make money by selling a product. The art market is extremely competitive and except for a few of the very largest firms and most prominent dealers, participants in this market deal with cash flow issues and the constant necessity of making more sales.

Gallery owners and directors are in the business of trying to set market directions as well as sell individual pieces. This entails an added strain as it is always a gamble as to what new trend will catch on and which artists are going to be the next stars. Trying to determine ahead of time what the buying public will like can produce anxiety and stress. Another troubling liability is that the artist whose career you nurtured may suddenly leave you for another gallery just as financial success is in sight.

Gallery work is not unlike working in a performing arts environment in that it comes to own you. Getting the show on takes precedence over all other activities. This makes having personal relationships difficult, since you have little time to meet personal and social commitments.

Working with expensive objects can become a nerve-wracking experience. A painting is fragile, and so too are many of the art objects and sculptures you will be dealing with. Antiques present a whole other world of breakables to test your nerves.

Another aspect of an art market career that can be trying is the great number of oversize egos that must be dealt with. Artists, wealthy clients, and critics are often consumed with their own importance. If you are just starting out, you need to learn how to keep from telling off the self-important. You also need to learn to keep your own ego in check as you will no doubt be dealing with people who thrive on putting down people they regard as their underlings.

EDUCATION AND TRAINING

THERE IS NO UNDERGRADUATE college program that leads to a degree specifically as an art dealer. Most people who work in galleries or auction houses come to the profession with a degree in art history or with a background as a working artist. Others have education and experience on the business side, with credentials in management or accounting. Some have studied arts management.

You will want to have a college degree simply to be competitive with the other fledgling art dealers looking for the same opportunities as you. A degree in fine arts or in art history is typical preparation for employment in a gallery or auction house.

You can consider a business minor to go along with your arts major, or a business major with an arts minor. Another option is to consider majoring or minoring in a foreign language, one that will come in handy given the globalization of the art market. There are many French and German speakers in the arts world, but being conversant about art in Chinese, Arabic, or Russian could make you stand out in the crowd.

Another track is to consider a degree in Arts Administration. There are both undergraduate and graduate programs in Arts Administration that include courses specifically about gallery management. The Association of Arts Administration Educators offers a listing of some 40 undergraduate arts administration programs and about 60 graduate programs, although many are specifically theater management programs.

An example of the type of undergraduate course is Gallery Management and Exhibition Development, which is in the Arts Administration program at Albright College in Reading, Pennsylvania. According to the catalog, the aim of the course is to introduce students to all aspects of exhibition and gallery management. Using the on-campus Freedman Gallery as a resource, students gain hands-on experience about how to organize an exhibition from start to finish. Particular attention is paid to the concept of the exhibition, production schedules, writing didactic materials, and installation. Other topics covered include database management, storage and loans. As a final project each student creates an exhibition culled from the gallery's permanent collection.

At Purchase College of the State University of New York, the undergraduate Arts Management degree includes two Visual Arts Management courses. In the first, students learn the fundamentals of operating commercial art galleries, including curating, artist contracts, and developing client relationships. Additional topics include connoisseurship, detecting fakes in the art market, and the current regimen of high-profile art fairs. The follow-up class focuses specifically on curatorship and connoisseurship, offering a close study of important trends in the evolving field of visual arts management and the art market. Students develop curatorial skills for exhibiting artists and their artworks. The course also reviews problems related to attribution and forgery.

Of further note in the Purchase College program is Marketing for Artists in a Digital Age, a course covering the use of technologies designed for creating, editing, archiving, and sharing the images, videos, live streams, and audio content consumed across social and traditional platforms. Among other skills, students learn how to create original websites to feature their work. In fact, focusing on digital art skills could be a valuable asset toward your landing that first position in a gallery or auction house, as all business today must migrate toward an online presence.

An undergraduate degree is usually sufficient for getting started in a gallery or auction house. Having a graduate degree does increase your leverage, especially if it is a degree that is actually focused on gallery administration. Many graduate programs focus on theater management, and others on performing arts administration in general, rather than on visual arts. A notable exception and one worth investigating if you are willing to pursue graduate training is the program offered by Sotheby's Institute of Art. The Institute is a project of the internationally renowned auction house Sotheby's, with campuses located in four cities: Los Angeles, New York, London, and Beijing. In each one, the Institute has partnered with a major university to provide a comprehensive mixture of classes that bring together management skills and artistic sensibility.

For example, Sotheby's Institute of Art in Los Angeles is partnered with Claremont Graduate University's Center for Management in the Creative Industries (CMCI). This Center brings together faculty and curriculum from Sotheby's Institute of Art, The Drucker School of Management, the Getty Leadership Institute, and Claremont's School of Arts and Humanities.

While the programs vary between the different campuses, they all begin with the same first semester, an intensive introductory unit that explores six vital topics:

- Mapping the Art World: structures and networks

- How to Approach Art: from historic to contemporary; visual literacy

- The Art Market: history, development and emerging markets

- Collecting, Collections & Exhibitions: private, corporate and institutional

- Business & Valuation: concepts, finance, investment

- Law & Ethics: principles, cases, and authenticity

In New York, during the second and third semesters, students choose a degree program in which to concentrate – Art Business, Contemporary Art, or Fine and Decorative Art and Design – and also select electives to pursue their personal interests and professional goals.

If pursuing a graduate degree is more academics than you care for, you can still have a Sotheby's experience by enrolling in its online program. This is not a degree program but a series of intensive six-week courses that offer a deep understanding of pivotal art history movements and of the key concepts and challenges of the art market. The Institute changes the course frequently, so you can take it repeatedly. Successful completion of each course leads to a Certificate of Completion from the Institute of Art.

GOVERNMENT FIGURES DO NOT TRACK salary data for art dealers specifically. Some industry participants suggest that the figures collected for museum workers may offer information comparable to that of the earnings of workers in galleries and auction houses. For example, the median salary for museum curators in the US, whose work roughly parallels that of gallery directors, is about $60,000. This means that half of the curators earn above that figure and half earn below it.

The salaries of museum curators are in most instances steady. The income of an art gallery director or manager, may change year to year based on a variety of factors that can include the changes in the size of the gallery and the success of the gallery's operations in general, and the effect of any exhibits for which the director or manager had a high degree of responsibility.

Online job listings for art preparator indicate salaries that range from around $45,000 up to $55,000 depending on the location and size of the

gallery as well as the candidate's experience.

Museum archivists, whose responsibilities in the area of record keeping are comparable to archivists in galleries and auction houses, have a median annual salary of about $50,000.

Fine art appraisers often have incomes in the $40,000 to $50,000 range, depending on whether they are on staff with an auction house or are independent contractors. If independent, then their incomes can go up or down from that range, depending on the reputation they have earned in their service to galleries, auction houses, and wealthy individuals.

The median for museum technicians and conservators, whose work is similar to the conservators, registrars, and collections specialists in galleries and auction houses, is about $40,000. It can be the case that archivists, registrars, and other staff in a gallery or auction house may, like the directors and managers, have some flexibility in their income, with bonuses or profit sharing boosting core salaries.

Gallery assistants typically earn an entry-level salary in the mid- $20,000 range.

Gallery owners also face the flexibility of the market. Backing the right artist can bring in millions, while promoting an artist whose work, no matter of what quality, is in the wrong place at the wrong time can lead to losses for the year.

OUTLOOK

THE WEBSITE ART-COLLECTING.COM lists some 4,000 art galleries across the US. The information website Quora points to sources indicating about 6,500 galleries. The actual count may be larger than that, with many galleries located in smaller cities and towns where they are overlooked by national surveys. The website Art Career Project suggests the real count is closer to 23,000 art dealers of one type or another in the US. The publication Canadian Art lists hundreds of galleries across all the provinces of that nation.

Whatever the number at any one time, there are always new galleries starting up. Even as that happens, there are also gallery closings. All in all, overall growth for the sector is rather small. In general, galleries close because the costs, especially rent, outpace the income from sales, and investor support is hard to find and sustain. Salaries are cited as the second biggest cost to a gallery, so hard times mean layoffs. On the positive side, the growth of Internet art sales will provide new jobs.

Even if the number of gallery and auction house openings were increasing at a notable rate, so too would be the competition for available jobs. There are many people who love art, even if not artists themselves, and who want to work in the art world. They are willing to take low paying entry positions just for the opportunity to be part of the scene. Their academic credentials are good, and they have probably done some type of non-paying internship sometime during their school years in order to get a recommendation. You will need to consider taking the same steps in order to be competitive when you begin your job hunting in earnest.

GETTING STARTED

IN ORDER TO LAND THAT FIRST JOB you should be prepared to explore as many different entry points as you can. For this reason, if you have mostly focused your studies on art or art history, it is definitely time to fill in the gaps by taking some marketing and business courses. Galleries in general are often criticized for their lack of marketing and business know-how, even the successful ones.

The same holds true if you have put off learning a foreign language. The top galleries usually draw from an international pool of talent and have the language issue covered. Smaller galleries, where you may be starting out, may be more in need of talent with linguistic skills. In addition, being multilingual is a sign of sophistication, and always a plus in the art world.

This may be the time to take that web design class or some related computer courses. Galleries looking to expand their marketing by going online will appreciate someone with both Internet skills and knowledge of art.

You can also consider joining one of the associations for people who work in specializations related to galleries and auction houses. These would include the Association of Registrars and Collections Specialists, Society of American Archivists, and the Appraisers Association of America.

You could volunteer at a museum while job hunting, or better yet, try to find an actual paying job at a museum. It may not be the glamorous art world you envisioned when thinking of working in a gallery, but it will definitely give you experience and hopefully some recommendations.

A smart way of preparing for your career as an art dealer is to get ahold of catalogues from auction houses that are issued to show what they are offering up for sale. Many are available online. You can track the advance estimates and actual sales results to help get an idea of what the market values are for various works of art and antiques, building up a practical, real world body of knowledge about current trends and tastes.

Whatever the position you start out in, it is best to do mainly listening and little talking. You will, for the most part, be working among knowledgeable, experienced people from whom you stand to learn about the business. Be patient and have respect for the people who have survived in this challenging and difficult field. Remember, too, that hard work and enthusiasm tend to be noticed.

One last suggestion for getting started is to be appropriate. Visit some galleries and see how people dress and how they relate physically to clients. Are there any common threads in the different galleries in term of style and manner? Study, learn, and be prepared to fit in.

RESOURCES FOR STUDENTS
ORGANIZATIONS

■ **Academy of Certified Archivists**
www.certifiedarchivists.org

■ **American Institute for Conservation of Historic and Artistic Works**
www.conservation-us.org

■ **American Society of Appraisers**
www.appraisers.org

- **Antique Tribal Art Dealers Association**
 www.atada.org

- **Appraisers Association of America**
 www.appraisersassociation.org

- **Art and Antique Dealers League of America**
 http://aadla.com

- **Art Dealers Association of America**
 www.artdealers.org

- **Association of Registrars and Collections Specialists**
 www.arcsinfo.org

- **Confédération Internationale des Négociants en Oeuvres d'Art**
 www.cinoa.org

- **Fine Art Dealers Association**
 www.fada.com

- **International Society of Appraisers**
 www.isa-appraisers.org

- **National Antique and Art Dealers Association of America**
 www.naadaa.org

- **National Auctioneers Association**
 www.auctioneers.org

- **New Art Dealers Alliance**
 www.newartdealers.org

- **Ontario Association of Art Galleries**
 http://oaag.org

- **Private Art Dealers Association**
 www.pada.net

■ Society of American Archivists
www2.archivists.org

PUBLICATIONS

■ Aesthetica
www.aestheticamagazine.com

■ Artnews
www.artnews.com

■ ArtReview
http://artreview.com

■ Art+Auction
www.blouinartinfo.com

■ Art in America
artinamericamagazine.com

■ Canadian Art
http://canadianart.ca

■ esse Arts and Opinions
http://esse.ca/en

■ Fillip
http://fillip.ca

■ International Artist
www.internationalartist.com

■ Interview
www.interviewmagazine.com

■ Juxtapoz
www.juxtapoz.com

■ KIOSK
http://kiosk-magazine.co.uk

■ Modern Painters
www.blouinartinfo.com
/subscriptions/modern-painters

■ RawVision
http://rawvision.com

■ Sculpture
http://sculpture.org/redesign
/mag.shtml

■ The Artist's Magazine
www.artistsnetwork.com/the-artists-magazine

■ Wallpaper
www.wallpaper.com

EDUCATION

■ Albright College Arts Administration
http://faculty.albright.edu/artsadmin

■ Association of Arts Administration Educators
http://www.artsadministration.org

■ Claremont Graduate University
Center for Management in the Creative Industries (CMCI)
cmci.cgu.edu/arts-management

■ Purchase College Arts Management
www.purchase.edu/Departments
/AcademicPrograms/arts/ArtsManagement

■ Sotheby's Institute of Art
Graduate School of Art and Its Markets
http://www.sothebysinstitute.com

Copyright 2017
Institute For Career Research
CAREERS INTERNET DATABASE www.careers-internet.org

www.ingramcontent.com/pod-product-compliance
Lightning Source LLC
Chambersburg PA
CBHW061239180526
45170CB00003B/1366